BATTLEDEXX
OFFICIAL
Manga & Anime
Colouring Book
Book 1

ISBN-13:
978-1537749235

ISBN-10:
1537749234

All illustrations, artwork, graphics, logos, animation, design, and text in this book are the exclusive copyrighted works of DEMON PIG STUDIOS . ALL RIGHTS RESERVED. Any unlawful redistribution or reproduction of artwork featured on this site without prior express written authorization of the copyright owner is strictly prohibited. Please consider that it is cheaper and safer to purchase, lease, or license art directly from the artist than to download/use images without permission and run the risk of costly litigation, and attorney's fees.

ARTWORKS BY
Narisawa Togai, Yoshiya Masahiko, Yanagi Kado,
Kobashigawa Kanko & Nishimura Aemi

Featuring Concept Art from Battledexx, Resident Evil & Senran Kagura
Artwork is owned by Demon Pig Studios, All Characters belong to their respective owners.

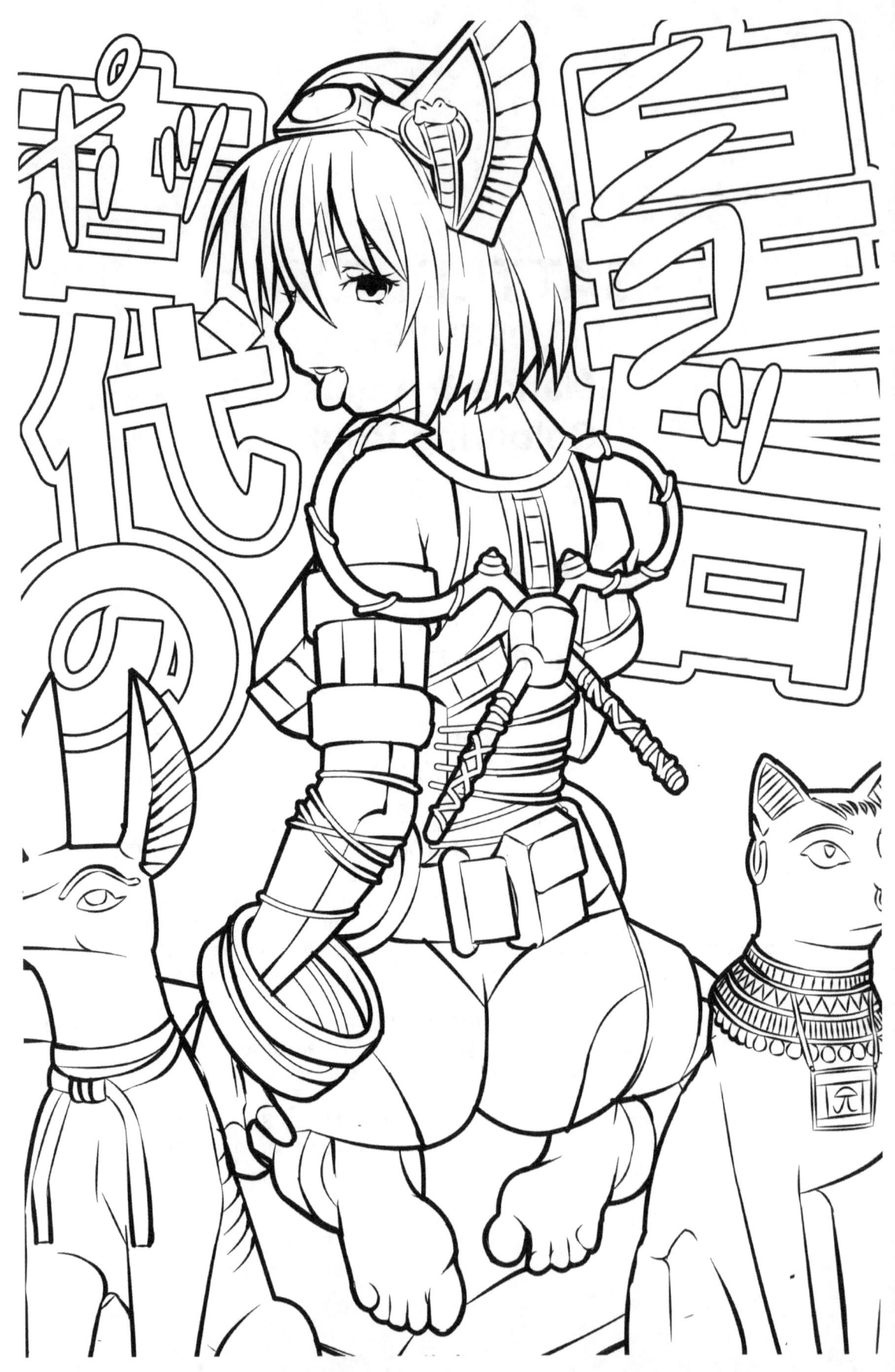

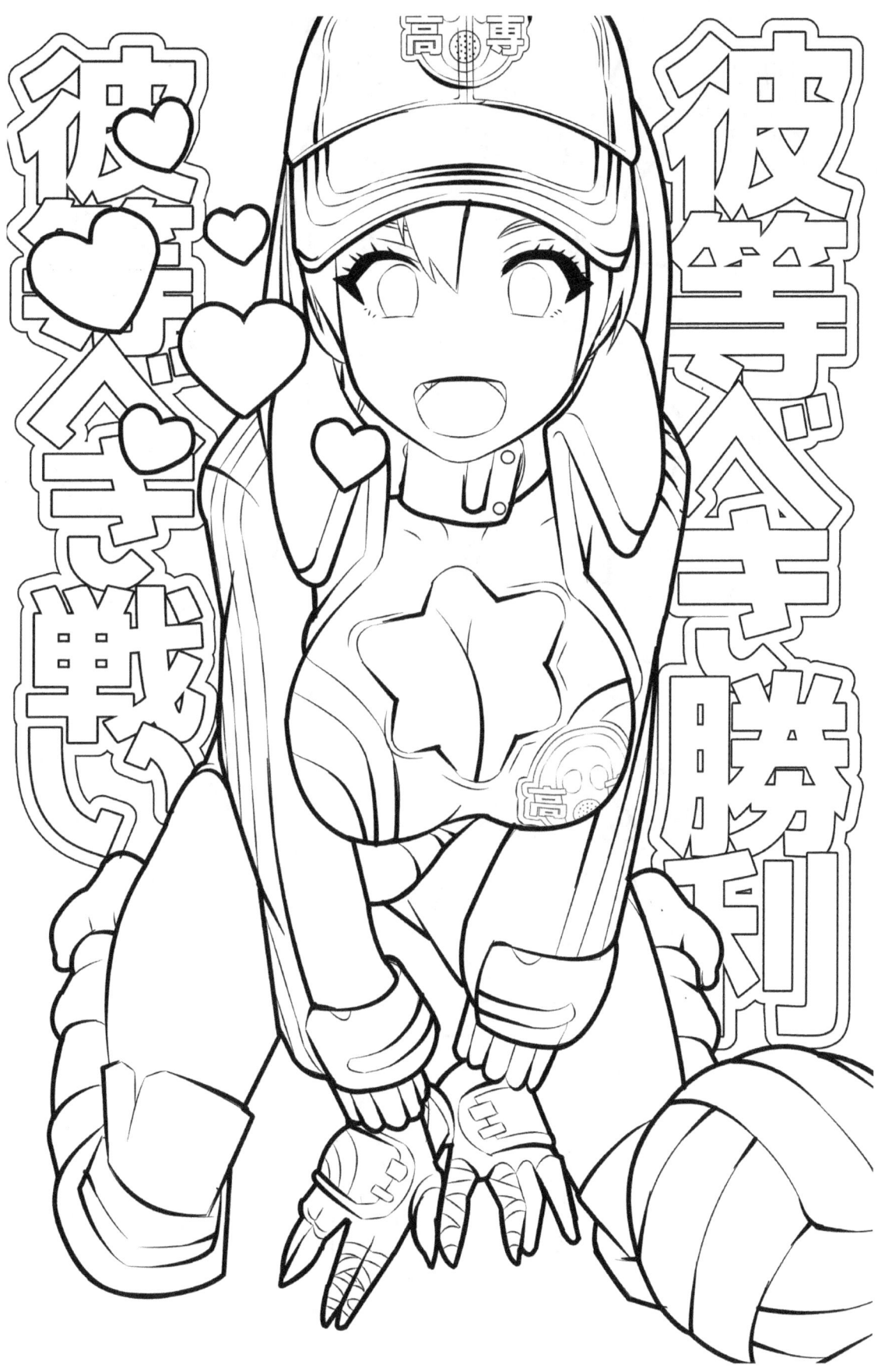

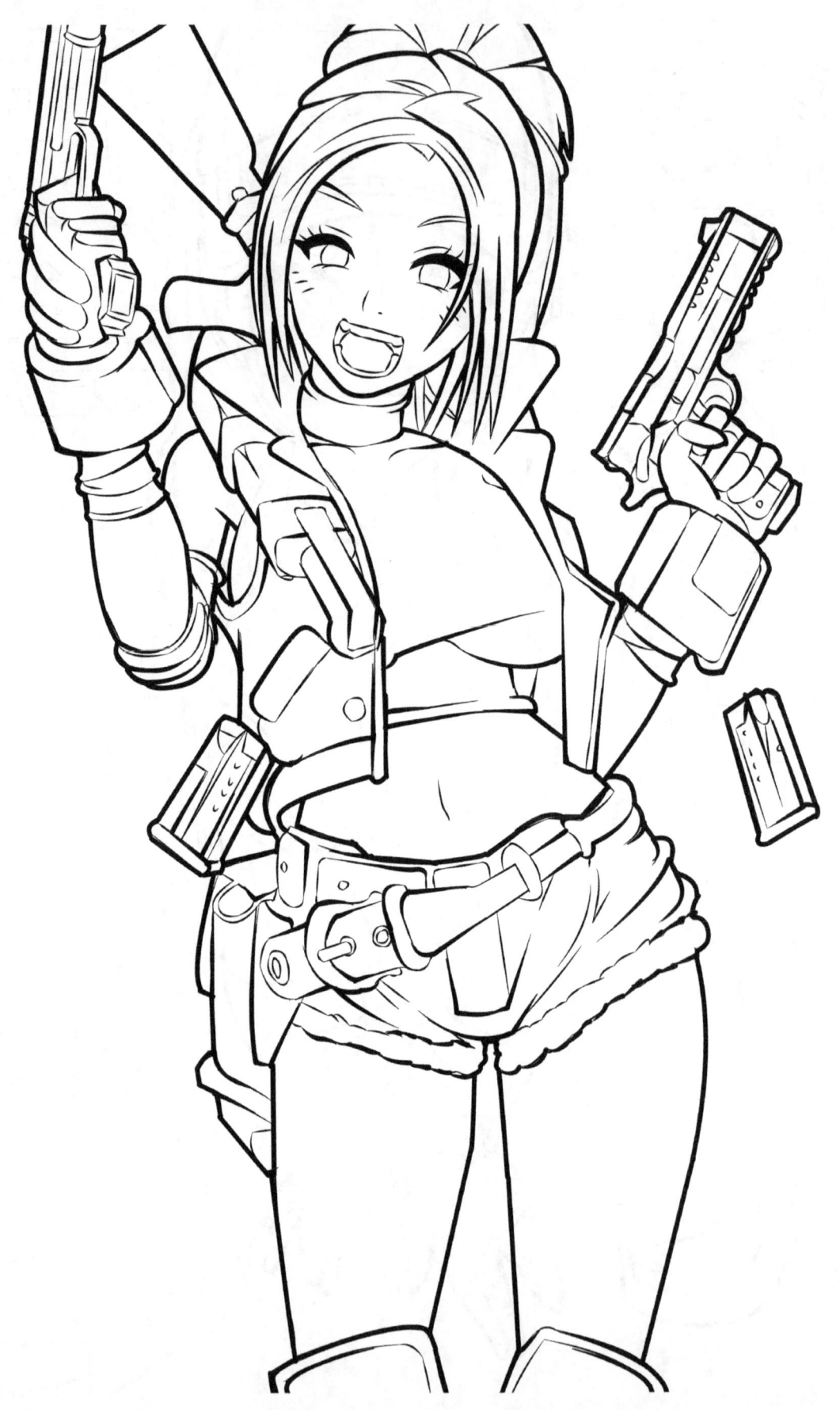

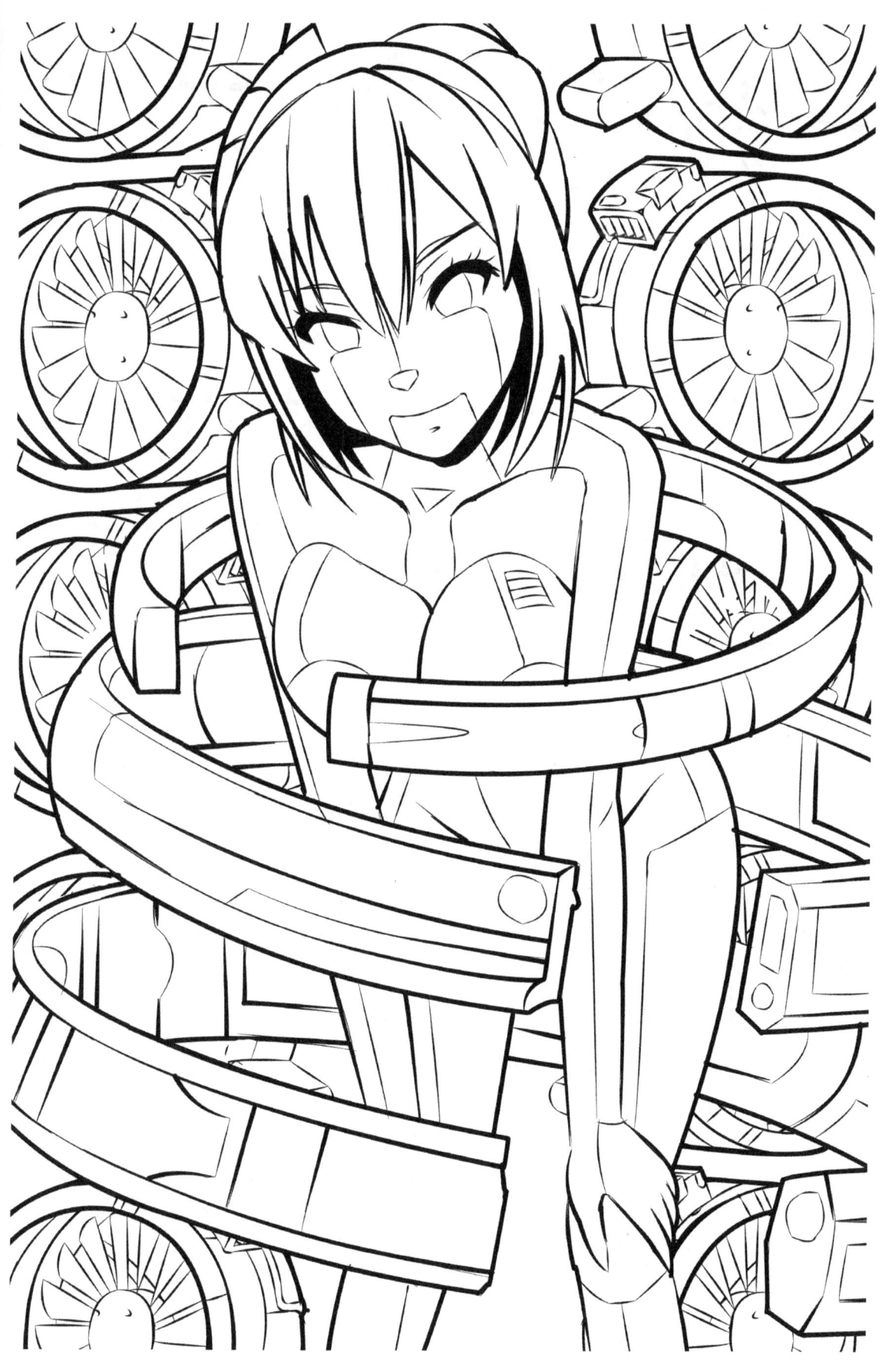

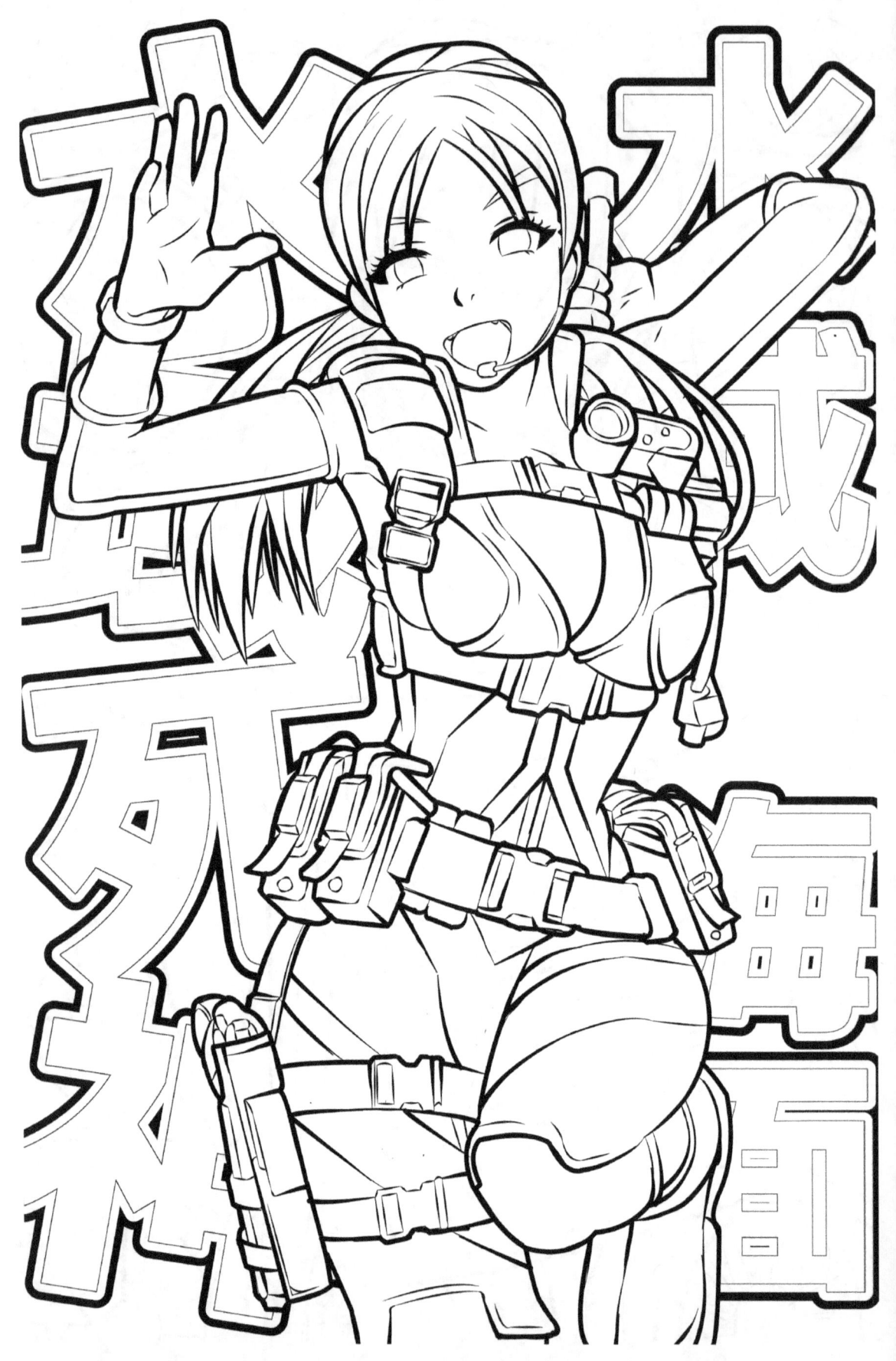

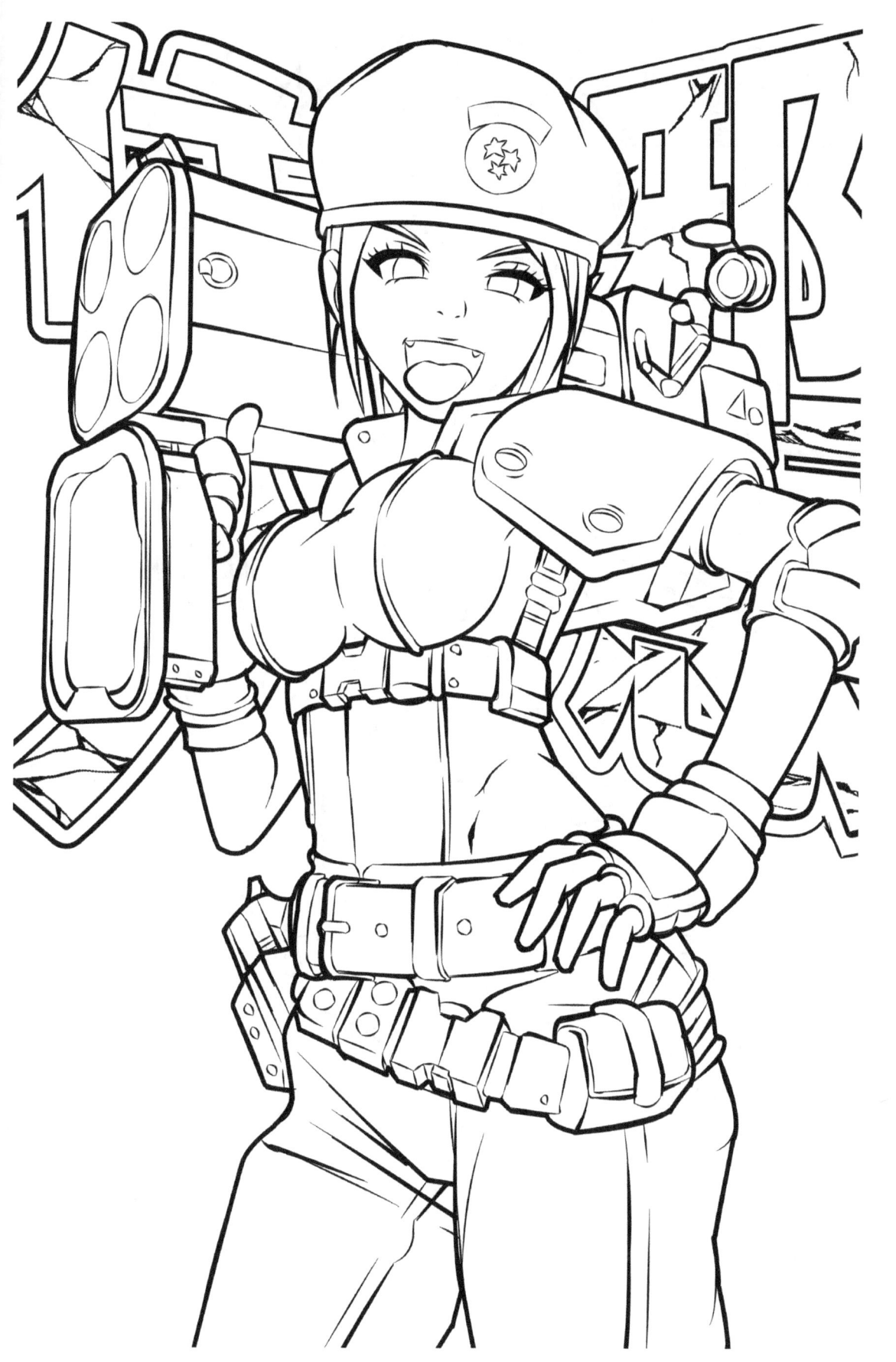

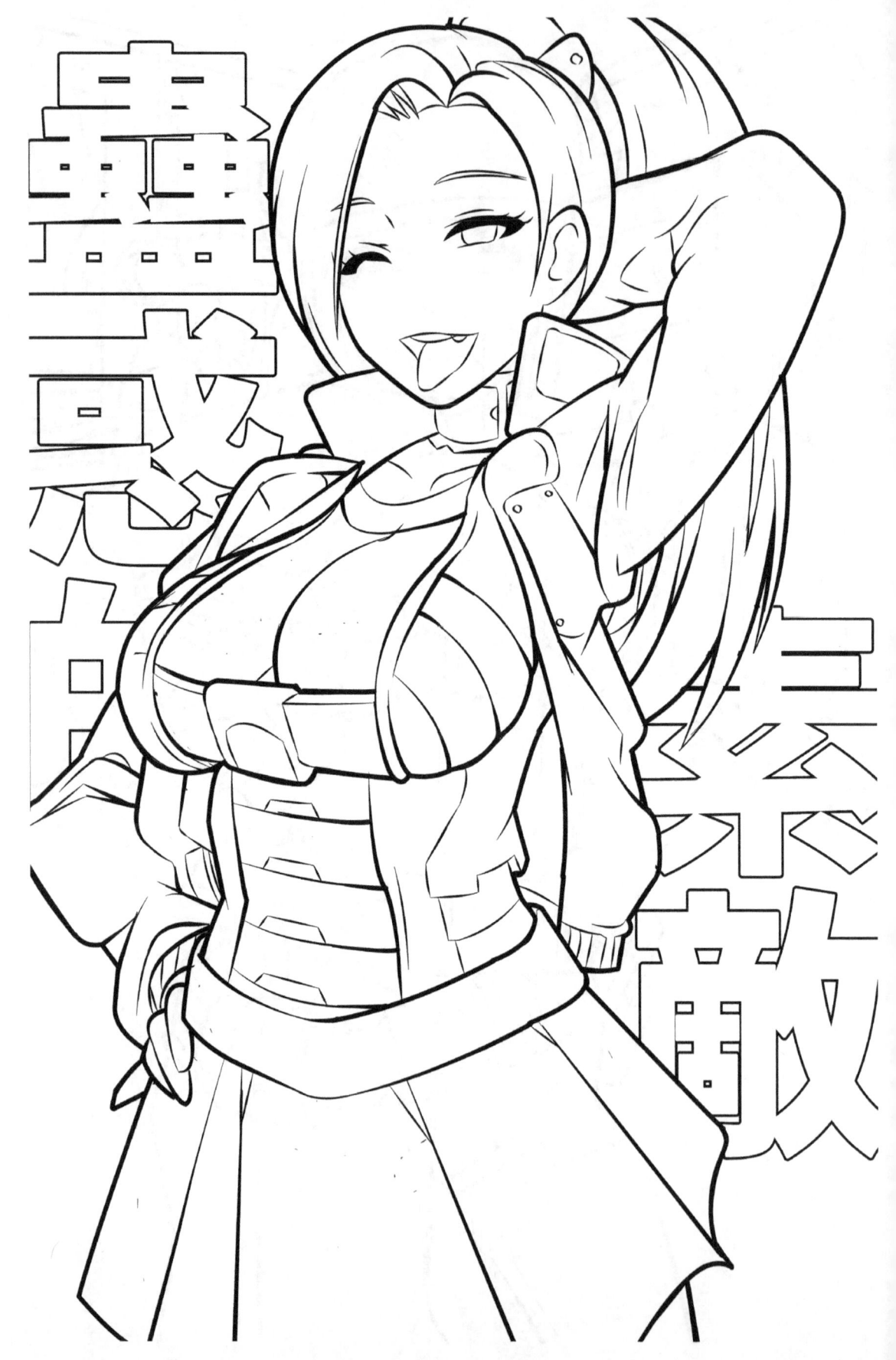

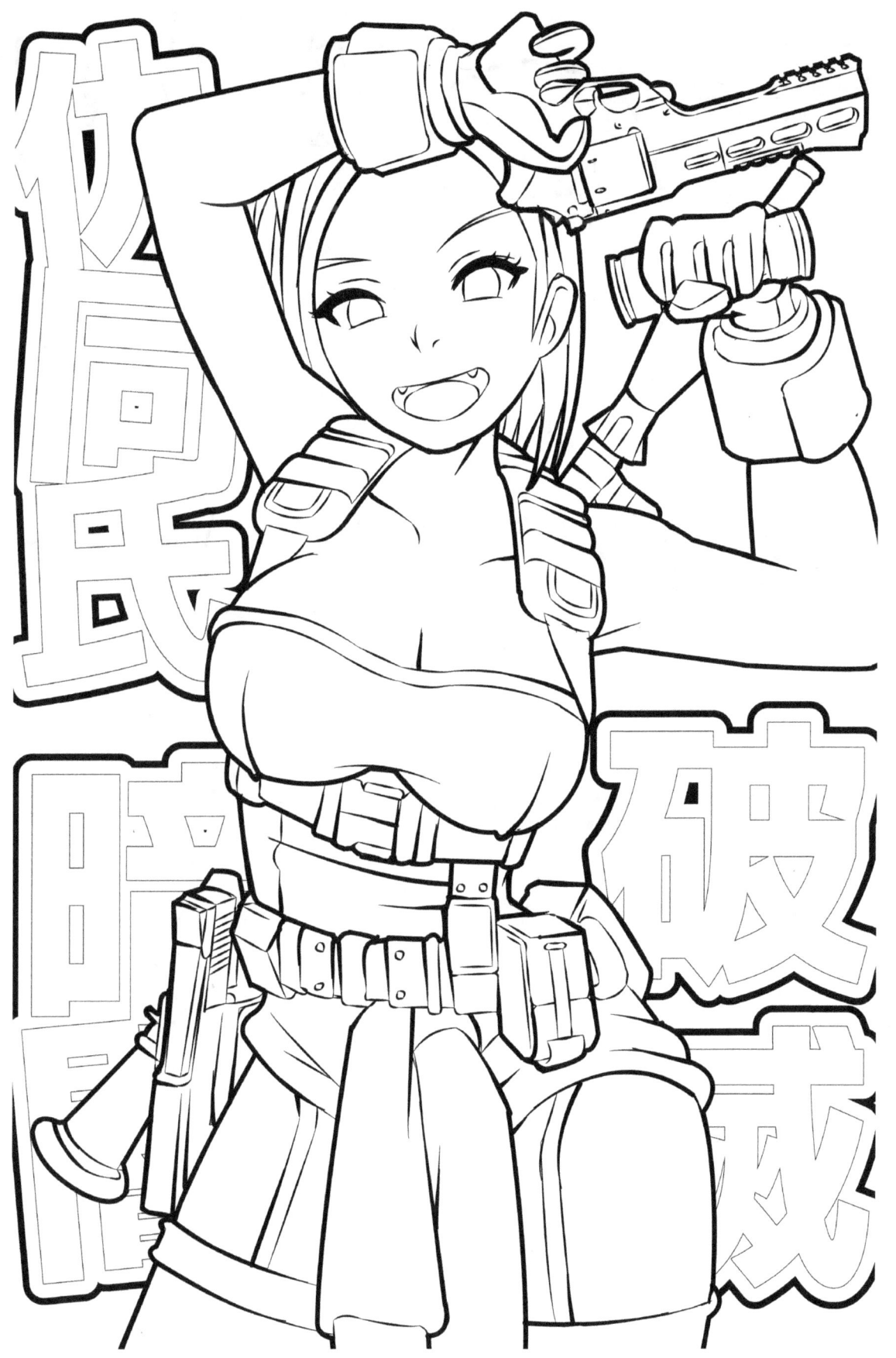

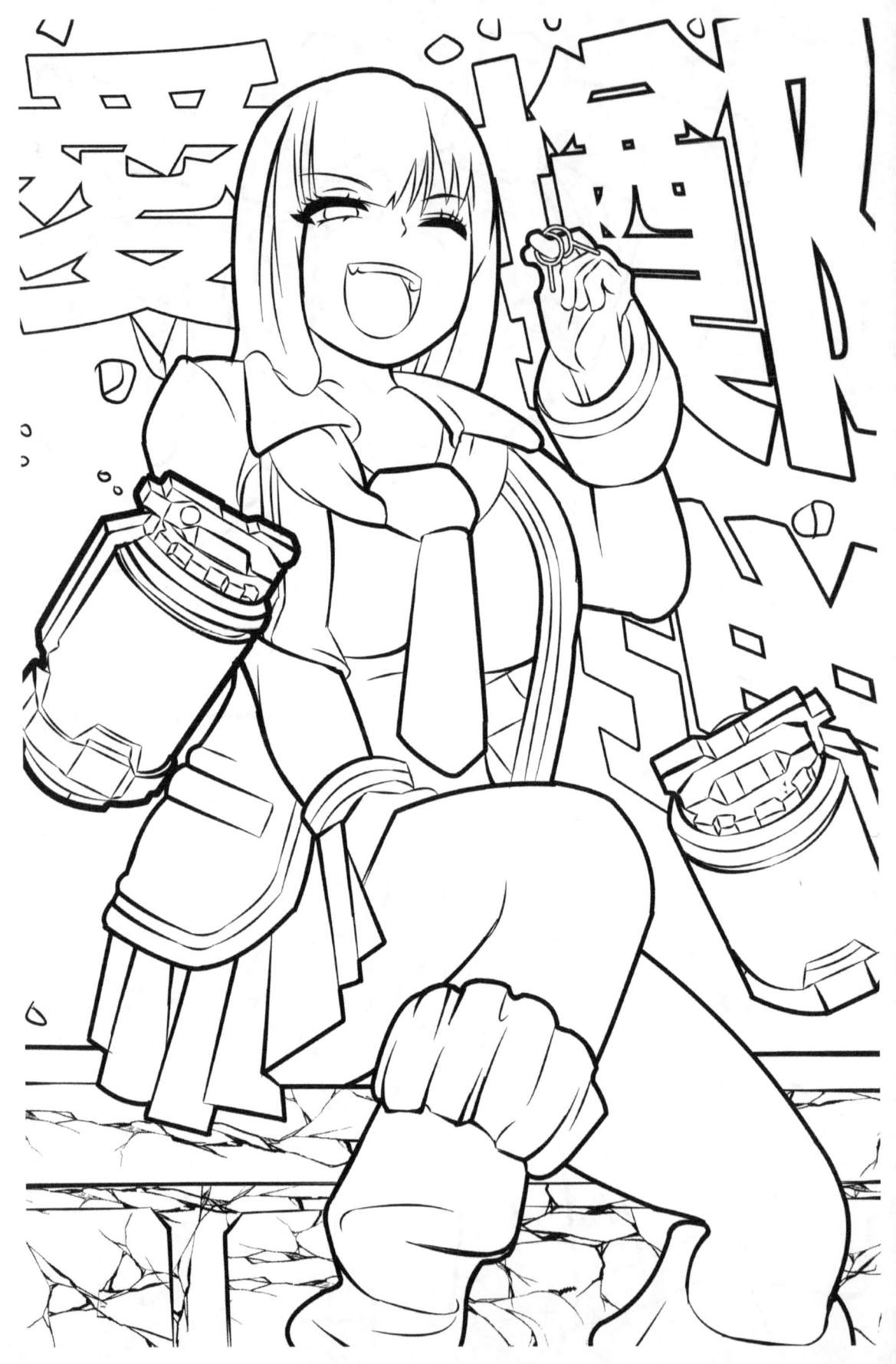

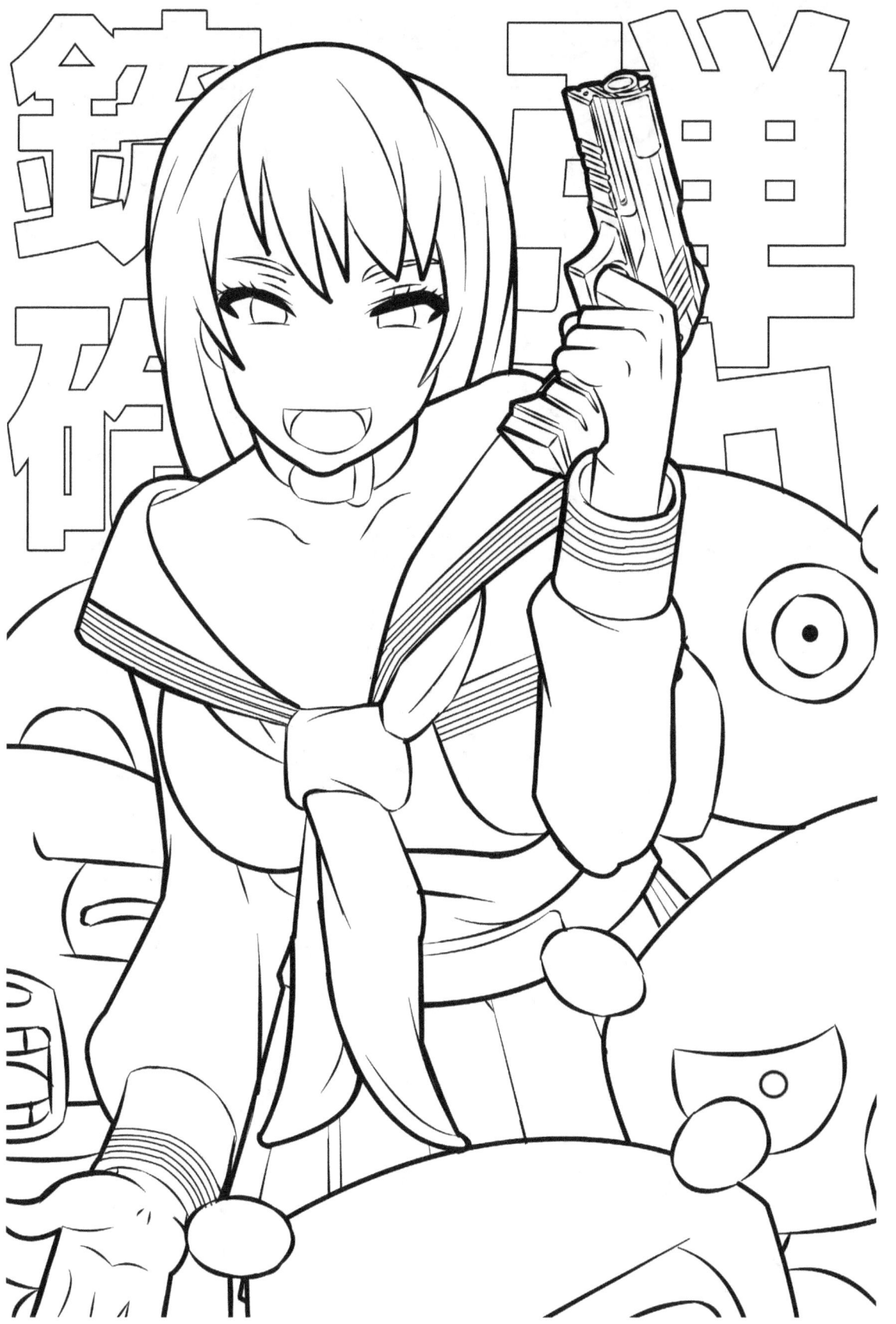

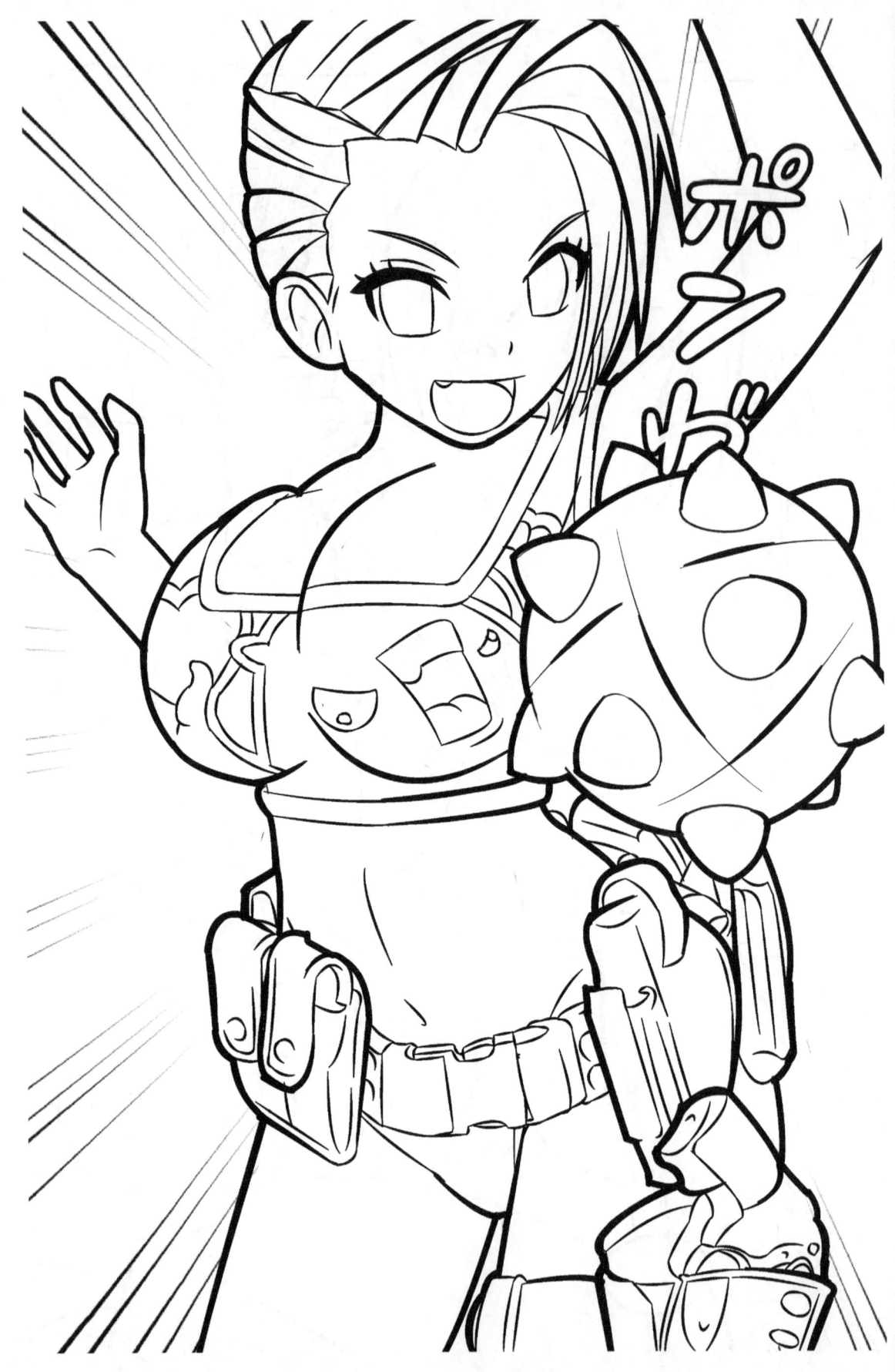

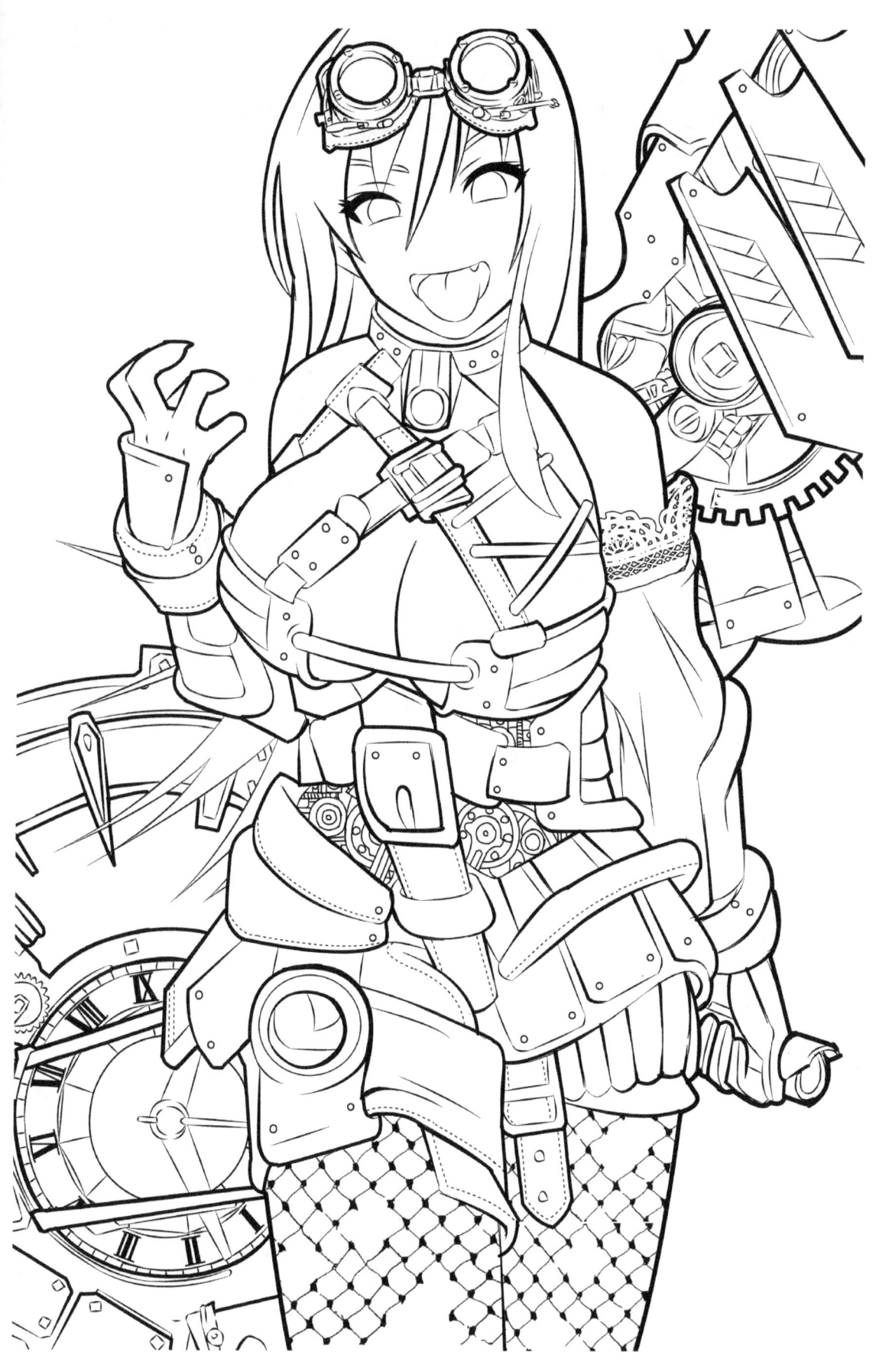

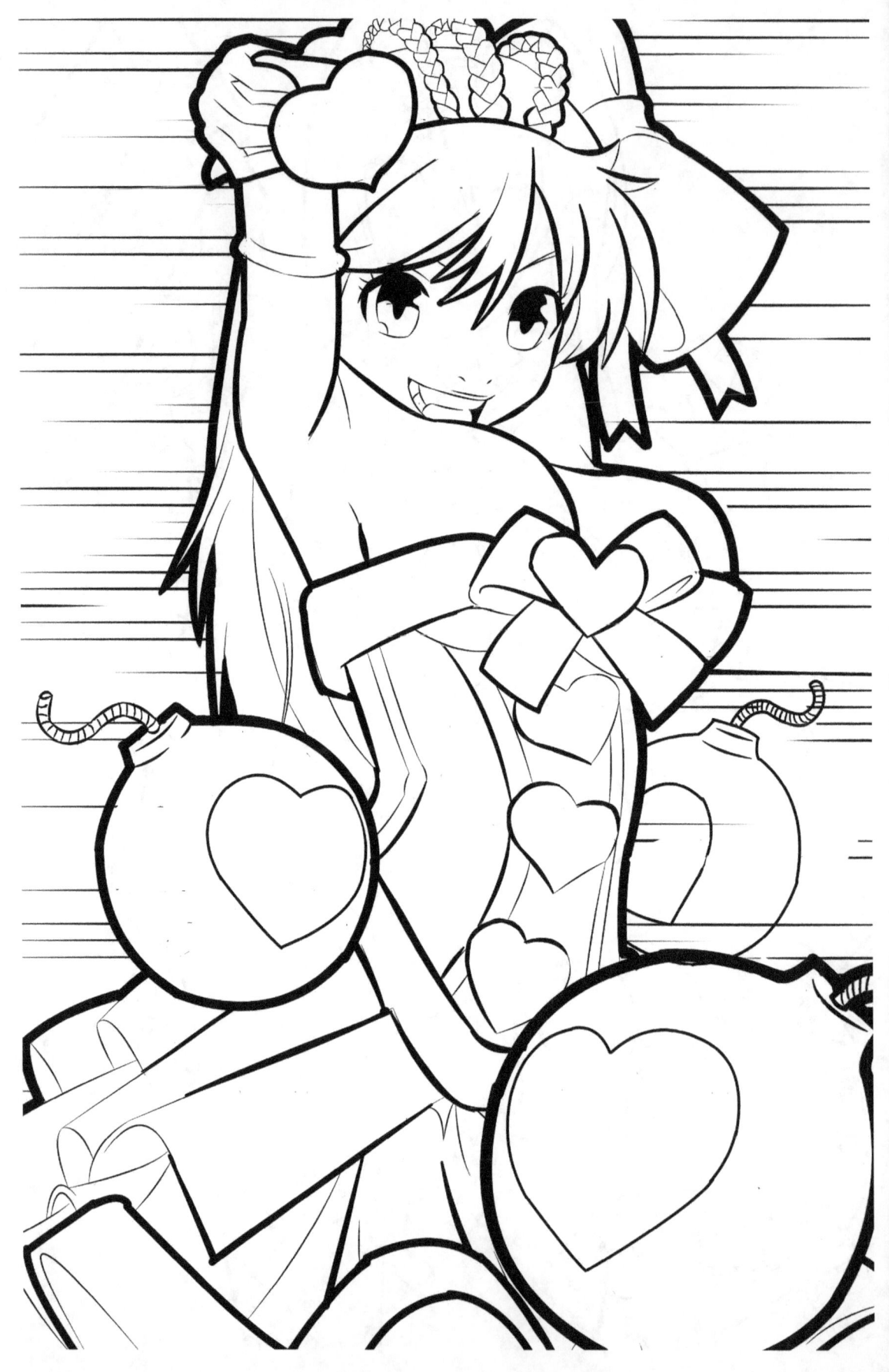

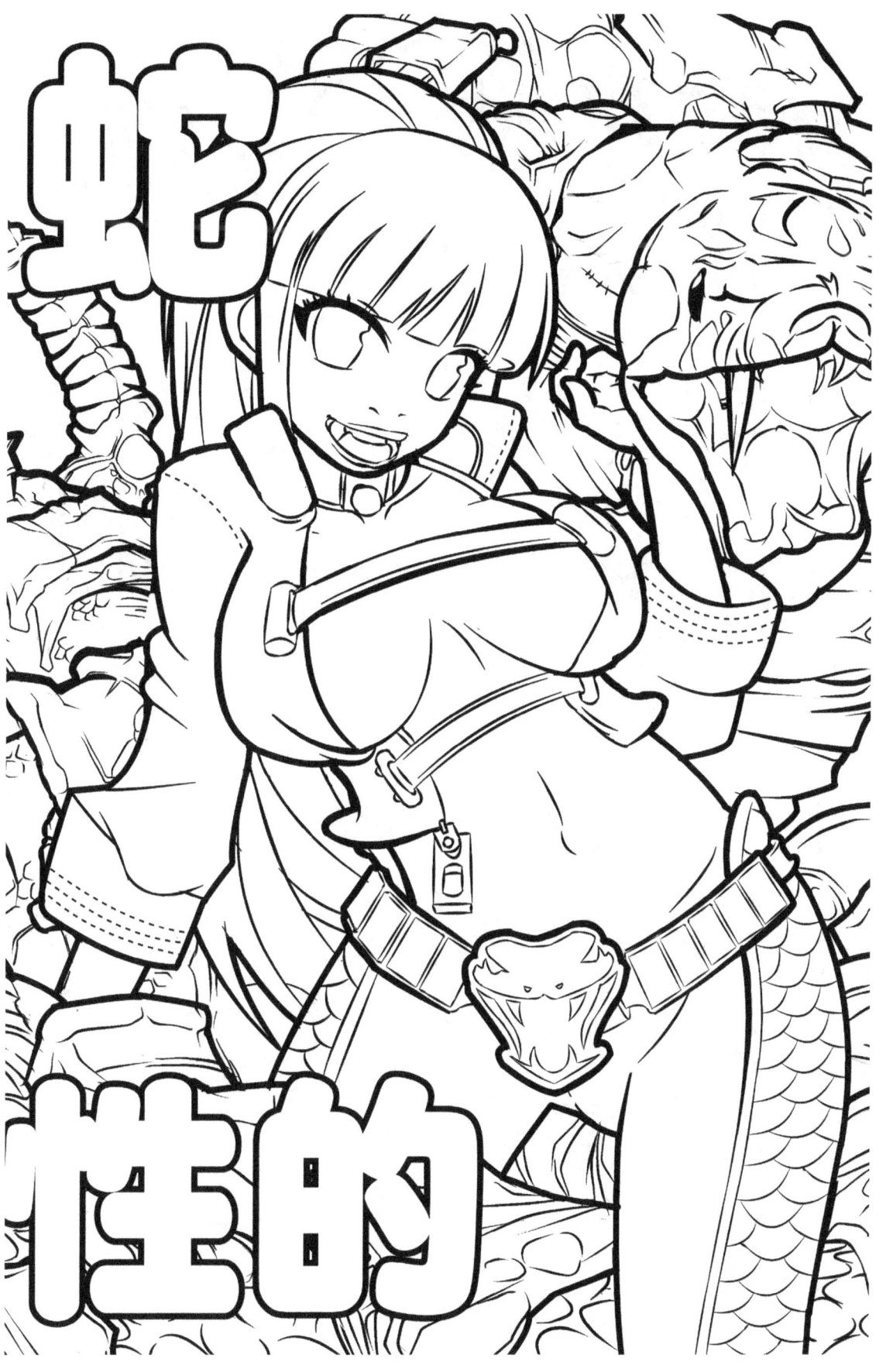

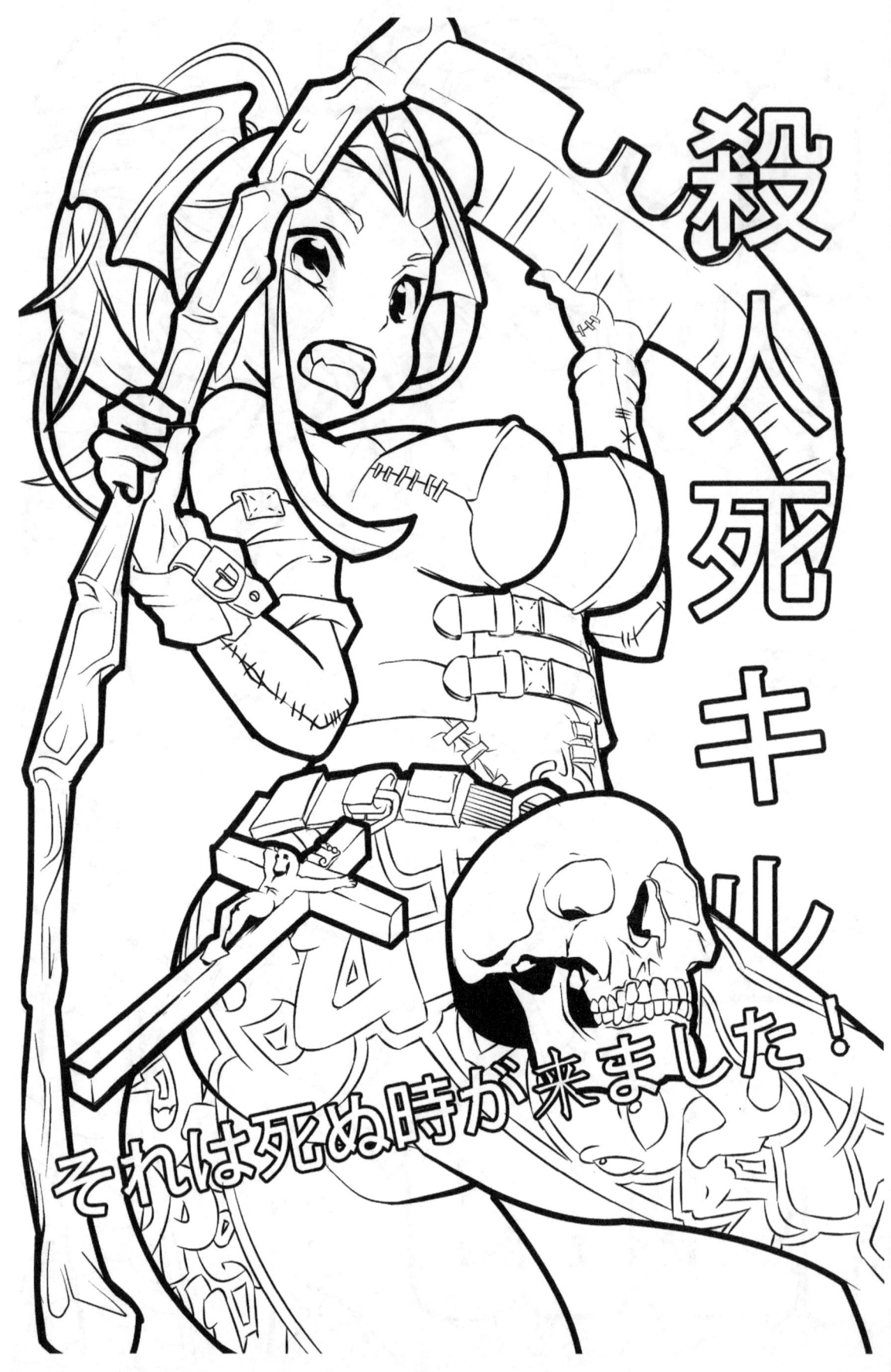

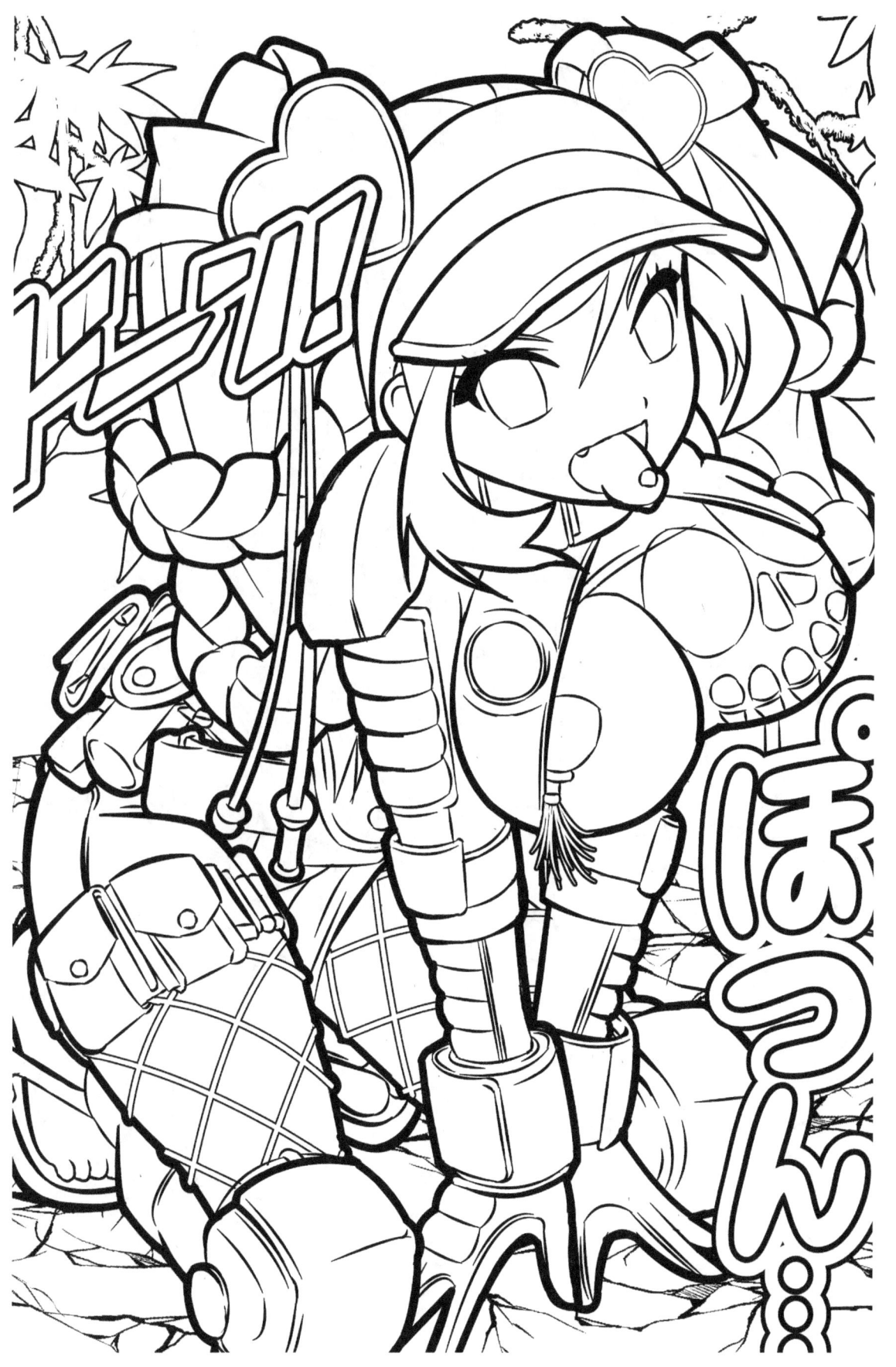

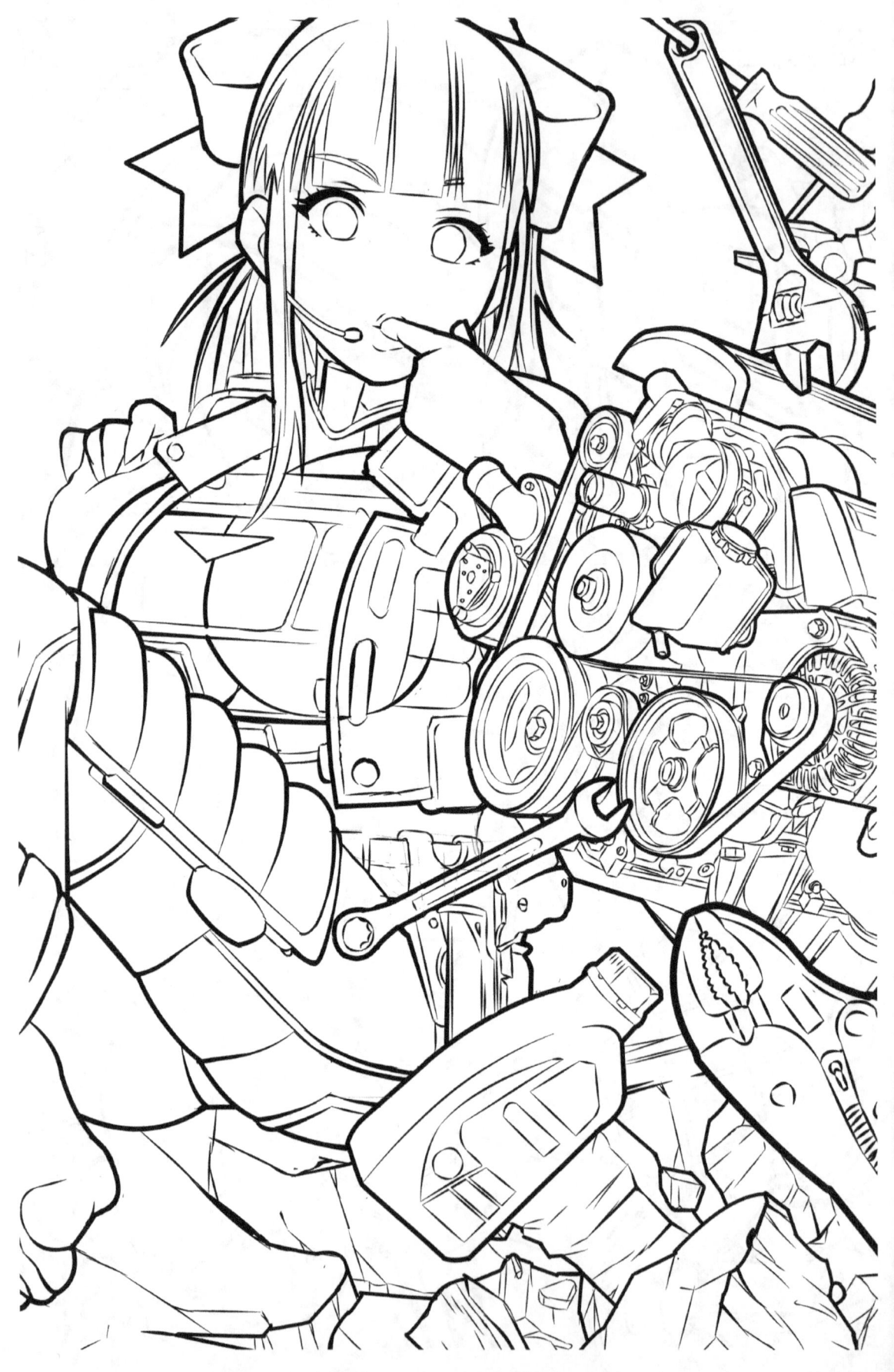

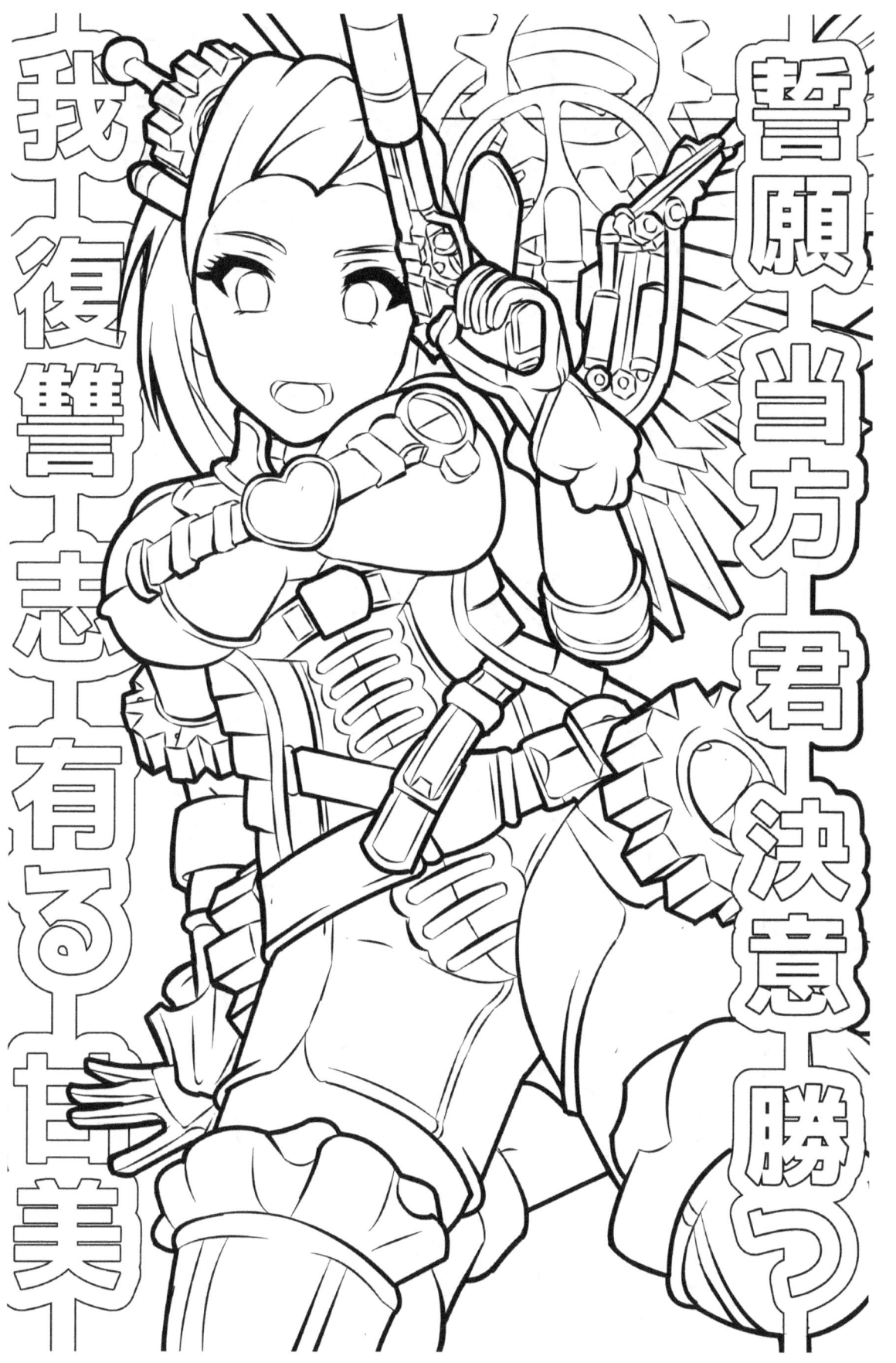

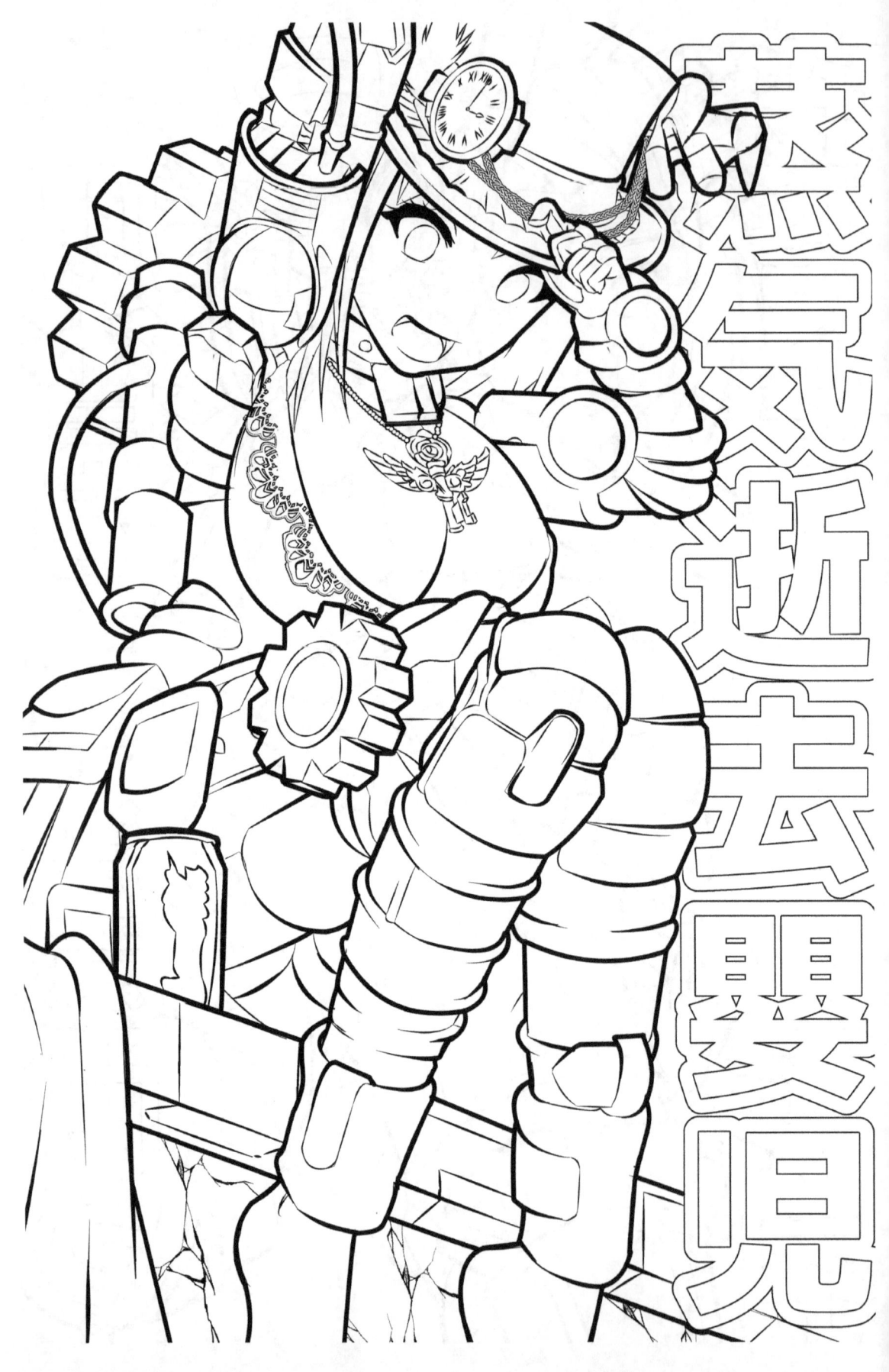

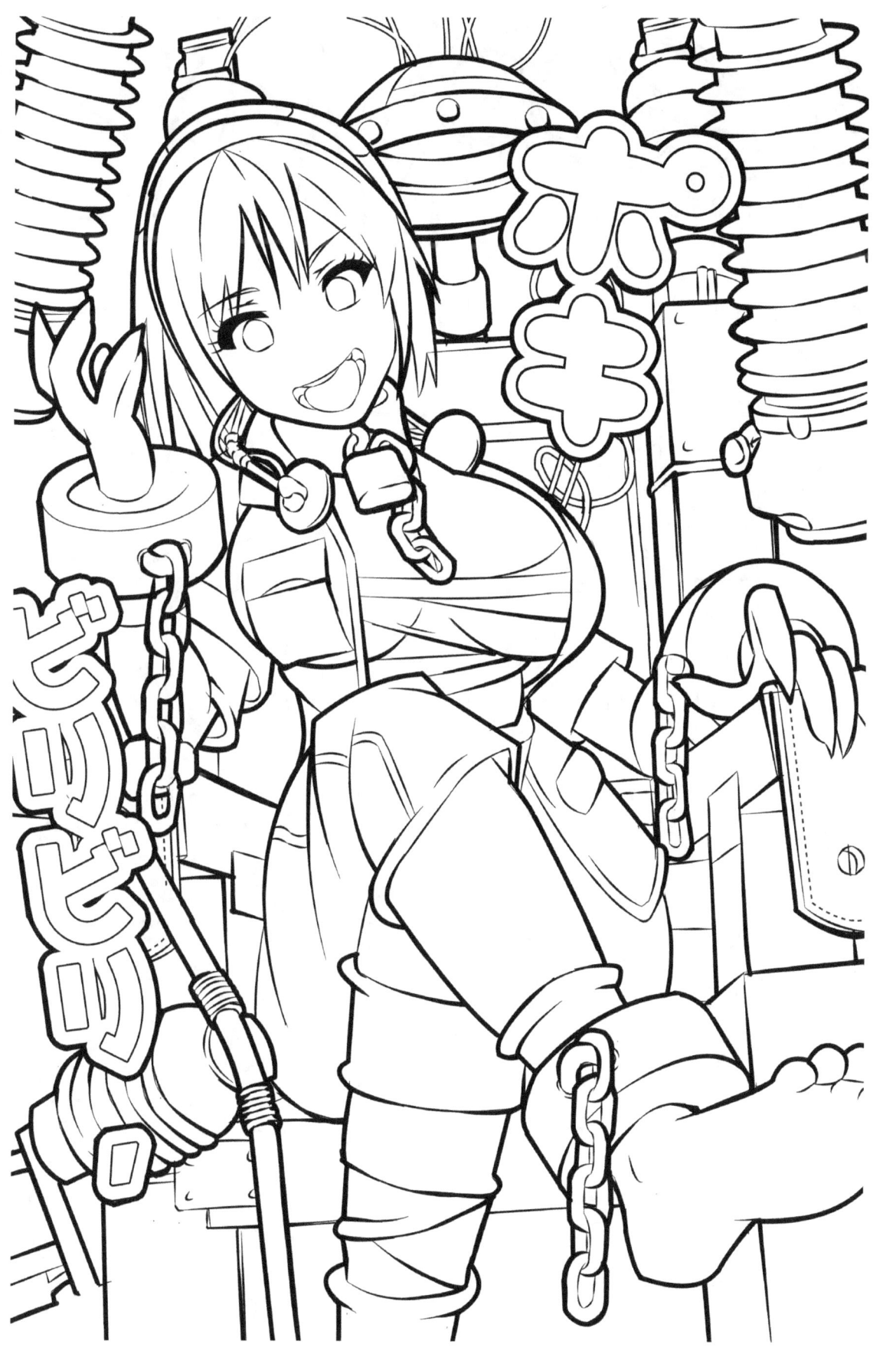

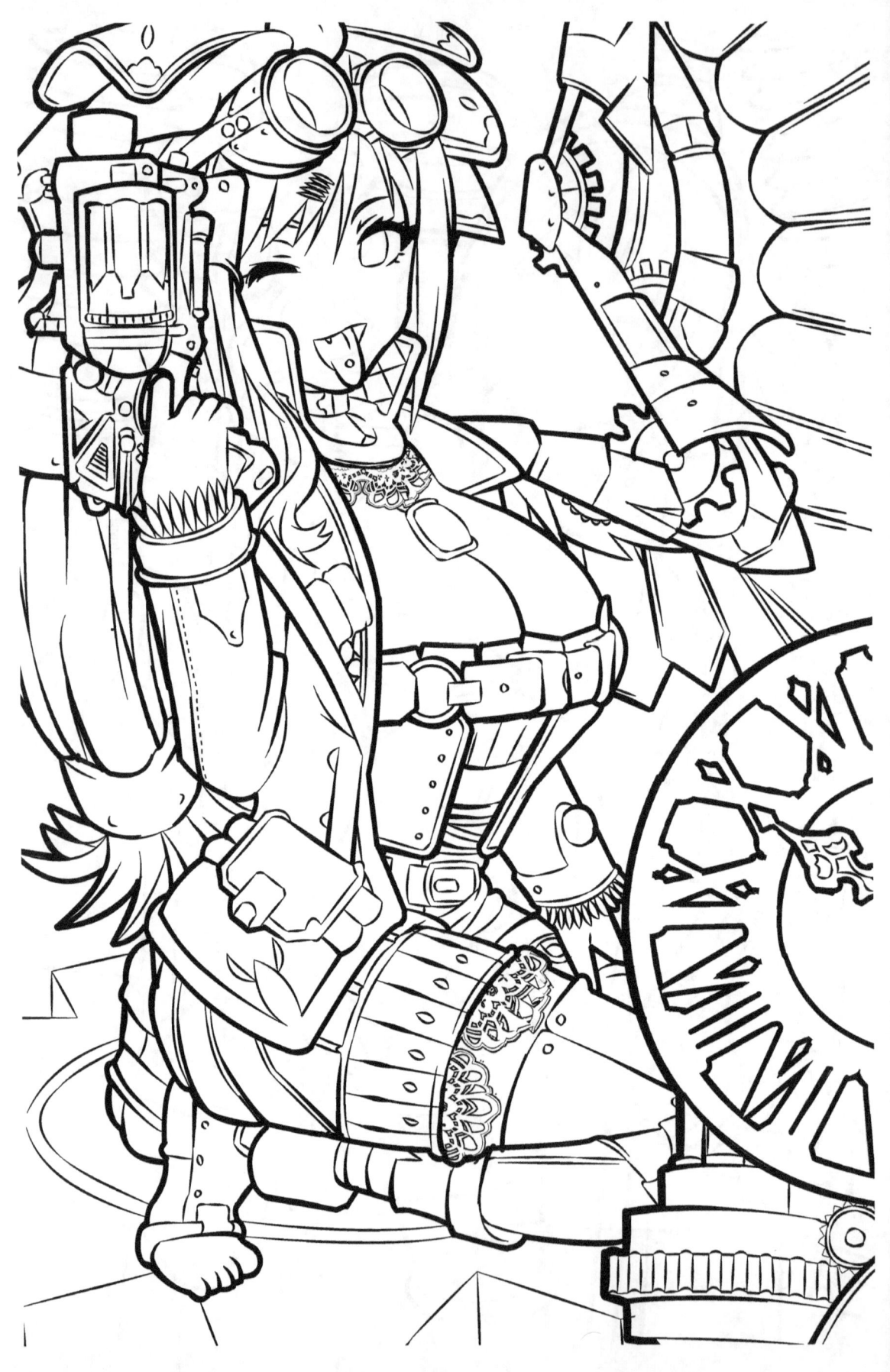

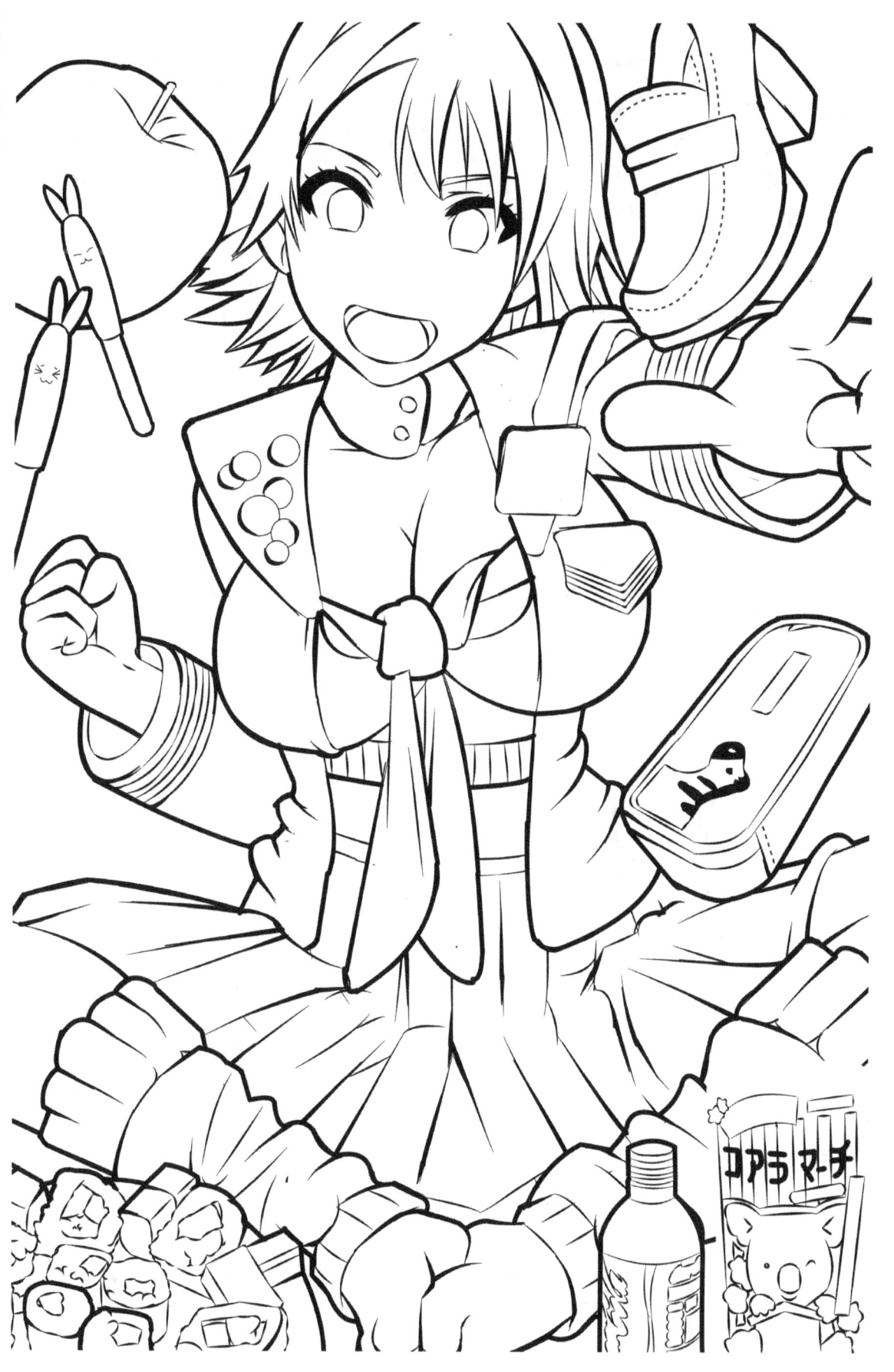

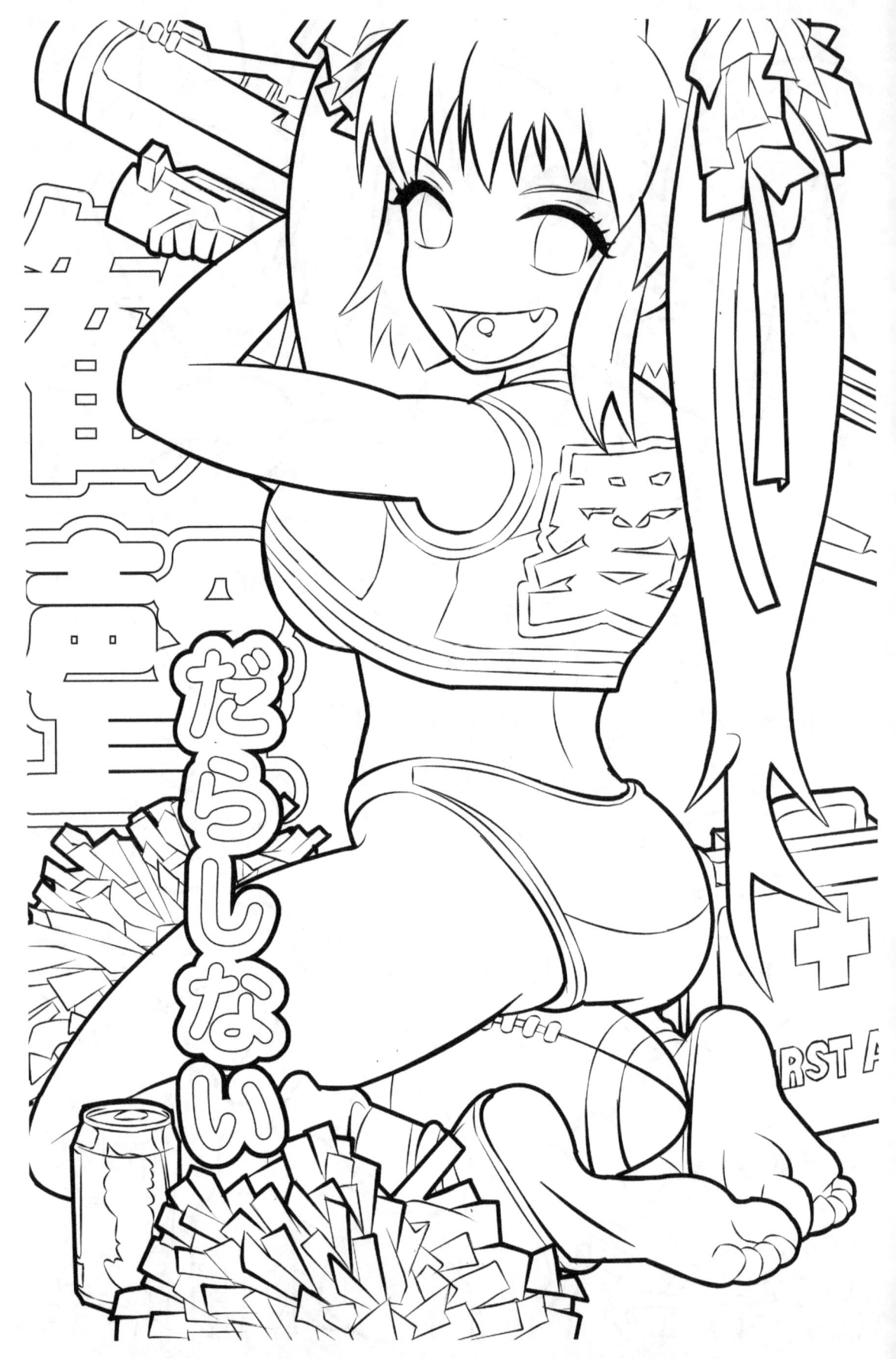

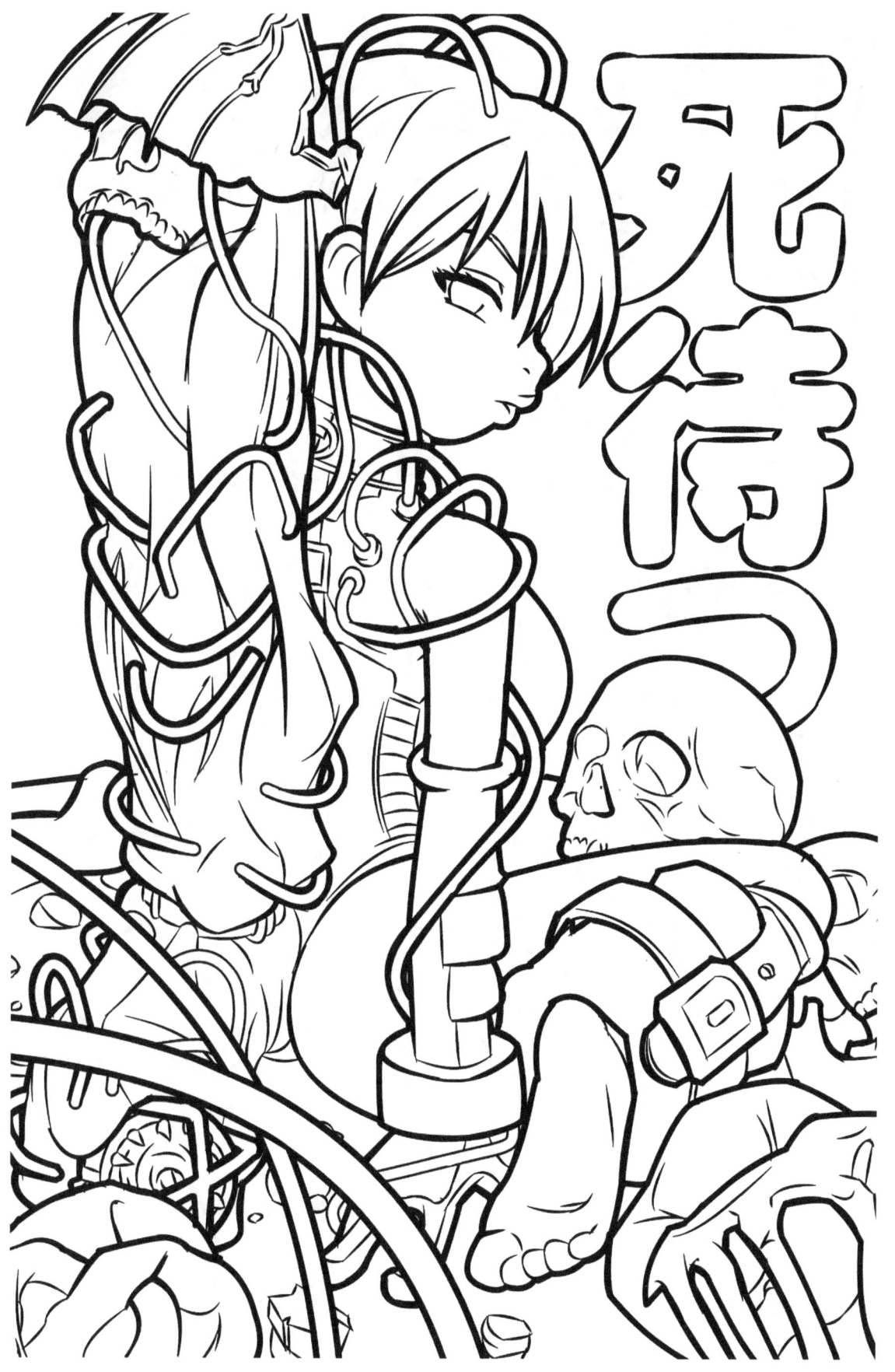

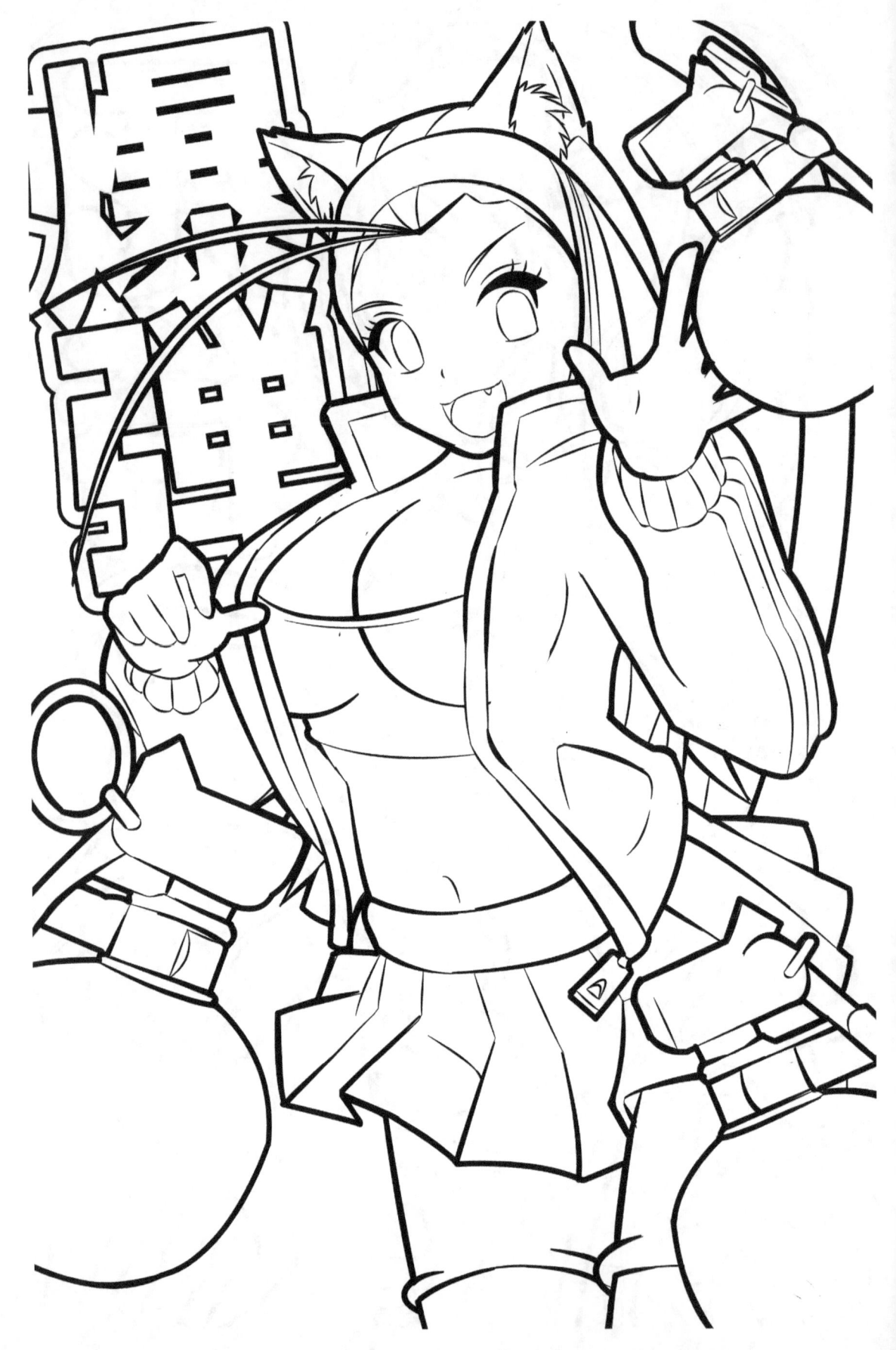

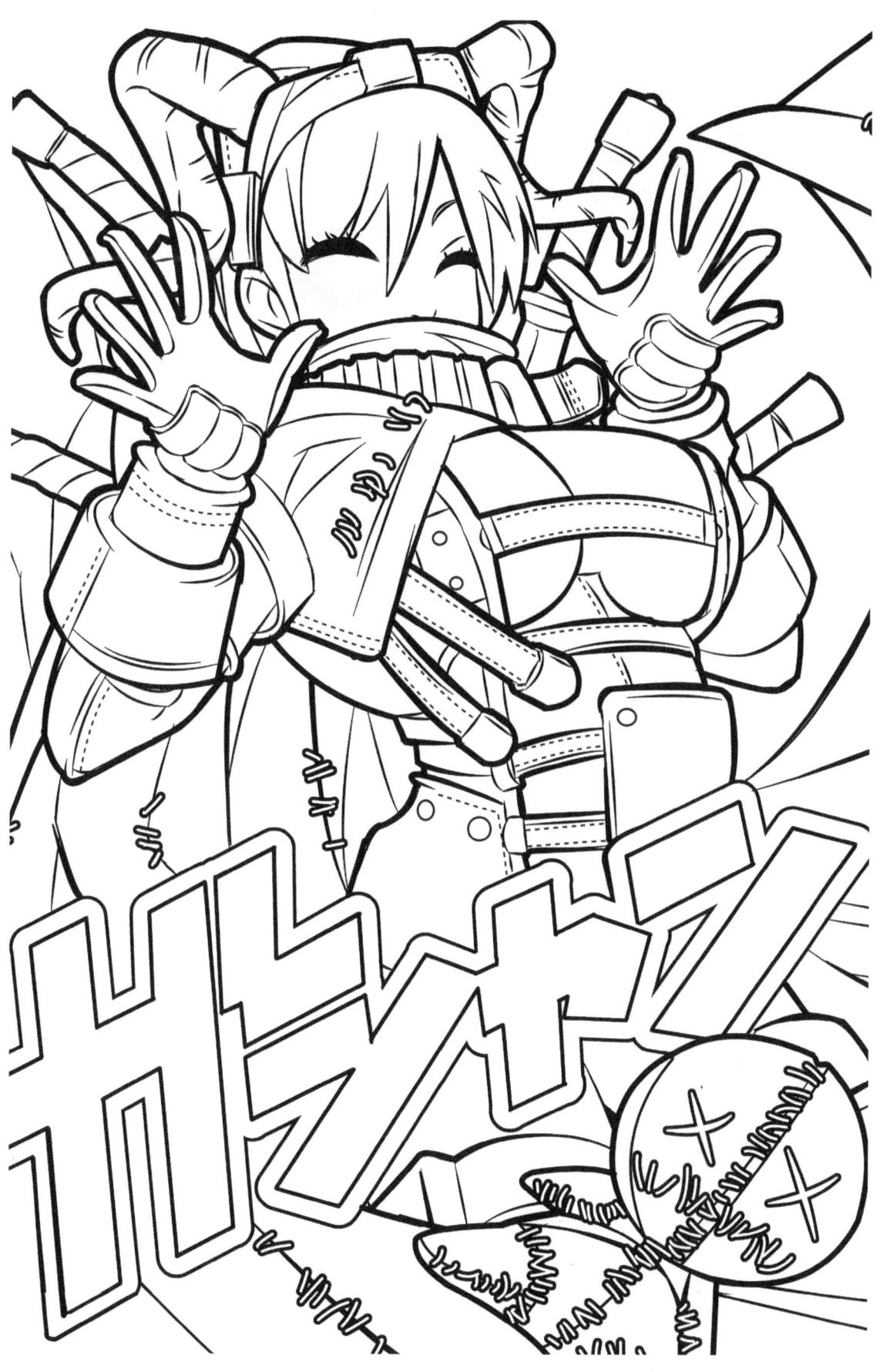